PASSIONS & GRATITUDES

In Melanie Perish's poetry, the beauty of her language has found its true mate in her love of nature. Her landscapes, whether in cities, offices, mountains or streams, take us on a journey that is both musical and revelatory. Her people flow like rivers; her rivers speak in rhyme. Honor, tenderness, survival, and love weave together with fishing and family, friendship and faith.

These poems are about being a woman and knowing how to live. They are sensual, they are finely tuned. They are informed by a life lived close to the earth; they are transformed by a life guided by spirit.

Melanie Perish is passionate about her world and her words. For that passion, and the spirit of grace that guides it, we can all be grateful.

—Cheryl Lundstrom
Author of *Foreign Bodies*

PASSIONS & GRATITUDES

POEMS

MELANIE PERISH

Rainshadow Editions
The Black Rock Press
2011

Cloth Edition:
ISBN: 978-1-891033-57-5

Trade Paper Edition:
ISBN: 978-1-891033-58-2

Library of Congress Control Number: 2011939183

The Black Rock Press
University of Nevada, Reno Reno, NV 89557-0244
www.blackrockpress.org
Printed in the United States of America

Cover painting "Blue" by Craig Mitchell
Copy editing by Theresa Gabrielli

CONTENTS

Dedication

For my teachers:

Adrienne Rich, Audre Lorde, Marge Piercy, Alice Walker, Paula Gunn Allen, Judy Grahn, Joan Larkin, Chana Block, Beverly Tanenhaus, Tom Meschery, John Irving, Sallie Ann Harrison, Cheryl Lundstrom, Valerie Hurley, John Kern, Joy Harjo

For the people I would trust with my life, and have:

Cheryl Lundstrom, Darrell Peterson, Valerie Hurley, John Kern, Sallie Ann Harrison, Tim Jones, Bob Gabrielli, Sherry Redding, Cathie Hatch, Sara Lafrance, Mary Conklin, Sandy Raffealli, Karen McGee, Elaine Frankovich, Nadine Pillsbury, John Perish, Cressa Payne Perish, Jon Epps, Flynn Epps, Doug Epps, Rachelle Baylo Epps, Amy Zurek Carothers, Carrie Young, Darren Young, Dawn Lawrence, Maryanne Cameron, Mitch Klaich, Bob Blesse, Kelly Testolin, Charla Honey, Matt Smith, Tim Coughlin, Stefanie Sccoppettone, Marsha Naccarato, Ahmad Itani, Malake Itani, Maureen Molini-Blanford, Cherry Rench, Nick Klaich, Jeff Webster, Angie Dowdy, David Newcomb, Jimi Quinn, Kathy Hess, Tyrone Davis, Jan Studin, Karen Morrison Dreher, Jan Jenner, Irene Zahava

For the people who give me hope for the future:

Connor Cameron, Ian Cameron, Erin Kern, Reem Itani, Theresa Gabrielli, Aubrey Bremer, Brent Bremer, Emily Perish, Michael Perish, Jackson Epps, Madeline Epps, Brian Cooper, Charlie Casas, Maya Baylo, Tyler Carothers, Chloe Young, Dominic Burgarello, Alison McClanahan, Kody Weil, Katrina Weil, Megan Webb, Hank Kennedy, Abe Kennedy, Avery Sarman, Madelyne Klaich, Aubrey Klaich, Brian Hatch, Sharon Brown, Caroline Niederkofler, Maxanne Anderson, Rory Anderson, Sean Carothers, Ian Carothers

In memory of

Mara Kern, who still is with us in spirit, and
Warren (Doc) Epps and William F. (Bill) Pillsbury
Good men from the greatest generation

The following poems have appeared in the publications listed below:

"Conversations: Last Night", *Common Lives*, Fall 1983
"Saving Lives," *Notes of a Daughter from the Old Country*, Motheroot Publications, 1978
"Easter: For My Mother", *Wordweaving 3*, 1977
"Sunday Afternoon," *Notes of a Daughter from the Old Country*, Motheroot Publications, 1978
"Conversations: Veronica at Four", *Brushfire*,1987
"Steel", *13th Moon*, 1984
"Your Mother Taught You How to Fish", *Calyx*, 1982
"Learning to Fish: Live Bait," *Sinister Wisdom*, 1982
"Origins," Black Rock Press Broadside, 1989
"Fall Thoughts," *Swallow's Tail*, 1985
"Lines", *Utah Holiday*, 1984
"Kinship," *Notes of a Daughter from the Old Country*, Motheroot Publications, 1978
"November Morning," *Midway Review*, 1982
"First Fire", *Midway Review*, 1982
"View from the Hill," *A Hard Roe to Hoe*, 1981
"When Time and Travel," Black Rock Press Broadside, 1989

We Are Not Always

We are not always the wise woman,
the staunch healer, the constant midwife,
the one who culls the herbs
into the magic poultice.

We are not always mother and daughter,
the strong hands, the nipple's sweetness,
the arms that rock and rock
and give when need demands it.

We are not always earth and water,
nor two sheaves of wheat,
nor shells wet with repetitious waves,
the salt rim fresh on the thin smooth lip.

Sometimes we are the spinsters
who turn the wheel, but do not spin,
the mother's nag, the daughter's wanton anger.
Sometimes you are the river,

the river that threatens my field;
I am the wave that hurls its crest
like rocks
against your clapboard beach house.

Like atoms
we move,
owning weight, mass, momentum.
We are not always anything but ourselves.

PASSIONS

LONG DISTANCE CONVERSATION:
VISITING YOU IN MINNEAPOLIS

I have crossed the Mississippi
twice today. Never without thinking
Mark Twain – who never lived
in Minnesota – but who may have seen
the upper waters of the river
the timber pilings along the bank
the wood trestle north
of a fifties footbridge where
student, teacher, writer tread
above water while you and I
tread water.

Mark Twain saw but never ran
the Truckee River, lived in Nevada,
published the *Territorial Enterprise*
at the top of Geiger Grade.
This was long before
you and I began our own
enterprise: love certain
as Washoe winds
or the Mississippi cutting her own
and new bed.

I never pass through Virginia City
without thinking: Mark Twain,

who watched the chancy clouds
the startled valleys,
who dreamed the push and tend
of water in the high desert.
He wrote and ran opinions, news
in streams of black ink
and prose.

He would ask too
why you left Nevada – you a man who knew
the dream of gold, the gamble.
He would answer
the river called, the only one
talking trains, borders, bridges,
the banks of civilization.
I will try to write you news
once a week from the West.

CONVERSATIONS: THE NEIGHBOR'S CAT

I call and tell you how
to rid your flower beds
of the neighbor's cat.
Renter, she lets her feline
roam and spray, leave feces
in your new-turned earth;
nothing will grow.

You think of poison
except that Bast
would curse you:
Ancient Cat Goddess
all the sands of Thebes
all the stones of Dendur

would rise up in the wind's swirl
would sting your dreams
pummel your Twentieth Century garden
with the shards of cups
the chips of scarabs.

Now you will try cayenne
and mothballs ground to powder,
sprinkled as charm
and deterrent.

You wait and pray
sipping before your altar
wearing your sacred necklace
chanting patience patience
ssssssssssssss

CONVERSATIONS: LAST NIGHT

"Two women sleeping / together
have more than their sleep
to defend."

—Adrienne Rich
"The Images"

Last night I dreamed I was
a refugee, you tell me.
The Chicana ahead of me, the Navajo
held babies, you say, babies wrapped
in purple quilts. The quilts, Mary,
you pieced them together. But you
you weren't with me. We didn't know where
we were being sent. But I saw a billboard
red lettered beside the dry road
PROTECTION it said.

Last night I dreamed I was in
an old mine shaft, Anna –
silver. It could have been close
to the Shivwits reservation. I was
piecing together children. Just me, Anna.
You weren't with me. Every few steps
I found a severed arm clean cut
as a drum stick, a knee ripped
near the rock, a perfect eye – brown –
the retina swinging like a watch chain.

Last night I slept
after we'd washed the evening cups
after you banked the den fire
after our lips brushed ears
and heads rested on shoulders.

Last night we slept
after we'd come home from Cousin Edna's
after a dart game where I almost
hit a double bull's eye. Close,
you said. And Edna said: But close
only counts in horseshoes and hand grenades.
Last night we slept and dreamed.

SUMMER

When summer brings that heat beneath the skin
and turns the dusky sun, red thick to haze,
I watch the boats that heel as they lean in
to dock. I wonder at the nerves that maze
my ready fingertips – at arms that long
to circle his wide shoulders, her broad hips.
I think that different struggles made each strong,
that weight or distance helped define the dips
and curves of bodies that my mouth would yet
explore. I want to taste the fear and feel
the joy like fruit – and feel again. The set
of bodies warmer than this sun, the keel
of bodies drifting like the boats, the deep
of summer's heat and haze and sleep.

In The Father's House

When you spoke, he slapped you
and you did not cry; she would cry for both of you.
Wise at three, you went to bed
touching the hot sting –
sharp pain made sharper in the touch –
it burned like tears held back.
You watched it fade in the bathroom mirror
and brushed your teeth
standing on the phone book.

In your red flannel nightgown,
you clicked off the pink lamp,
hands over your ears.

 If you hadn't spoken
 he wouldn't be angry
 If you hadn't spoken
 she wouldn't be crying.
 If you hadn't spoken, then there would be only
 the light smell of clean sheets,
 the down pillow she bought you,
 the feathers of moon clouds,
 winged rivers of stars.

Face down in the creasings
you squeezed your eyes tight.
The darkness hid the dragons.

You heard them in your cave.
Sword scales clanked and
shouts shattered on walls.
They slammed their feet twice
and left.

The house strangely quiet,
you told yourself stories of castles
until you fell asleep.
Most nights you did not dream.

When she came in to kiss you,
your face was hidden in the faults
of the blanket.
Your fists could not
unclose
to take your mother's hand.

SAVING LIVES

for John Aune

The first day back
we were given:
four lists of policies,
three security guards
to aid in enforcing attendance,
two memos from guidance saying
that no student schedules
could be changed

and a bomb scare.

After work,
I drove back into the city and walked.

A man had an epileptic seizure
on Broadway.
The doctor,
still in her while lab coat,
took a hand-tooled briefcase
and put it under his head,
someone's thin wallet
between his teeth;
I called St. Luke's emergency
like she told me.

Maybe all of the children
in all of the schools
need to have daily seizures.
Maybe then we'd hear.
Maybe then we'd stop long enough
to keep them from dying.

They are in danger of swallowing their tongues.

Final Evaluation

It would be nice to write a pedestal poem, witty with word plays
about scholarly students, an energetic teacher
resplendent in a class of total involvement
that never happened.

It is better this way – better to say that there were days
when we both came to class
because we had to,
left disappointed in a poem or each other;

better to say that there were days I fiercely loved you in this
four-walled, bell-ringing field of words;
held the difficulty of that love in my hand
like a precious, jagged stone: light prismed to a glory of color.

You have said weeks of true things;
I offer only one:
I have taught you nothing –
our learning has been our own.

EASTER

For My Mother

The delicate pinks and greens of April,
did they bloom when I was born?
Blot out the wrench and grip-down pain
you never talk about.

The stir of this river breeze,
was it in the harbor flat
as you walked me –
me who could sleep only
in motion.

The Childcraft books
packed in some attic,
the ones you bought on the sly,
read to me before I could talk
are in these words,
in the books and notebook I carry.

Sitting above the water
eight hours, five hundred miles
away from you
I know
I would not have learned to love
this solitude as easily
without you –
at the cost of your own.

SUNDAY AFTERNOON

My mother listened to me
play the piano.

She brought the sewing tin
into the front room,
mended knees and
elbows with heavy thread,
with scraps of denim and blue plaid.
She didn't believe in iron-on patches
or waste.
Her head bent close to the needle,
her fingers fashioned tiny stitches
over and over and over.

At the upright piano
I practiced my scales again and again.
weaving thumb under finger.
I missed the B-flat on purpose
before I opened the big, red book.
When I played "The Spinning Song" –
the quick staccato, the sharp chords –
I could hear her listening,
checked to see her hands
resting in her lap.

Long after I'd finished,
I could hear my mother listening.

I embrace	Some totems more than
others	myself
They make meaning	teach me like the wolf
like the dragonfly	learning – reflective eyes
delicate as wing filament	strong as flight or hunger
I watch and listen	Over time I
fill each cell	feel my pulse
with the difference between	race and rest
illusion and right action	like learning and understanding

DIFFICULT CONVERSATION

She is trying to make you wrong.

Let her sound
like a shrike;
the words from her mouth
fall like dumb, dead birds
shot and dropping.
Let the blade of her tone
slice the air, but not your heart.

Let your heart not
fist its walls
close its chambers.
Let your heart hold her with compassion
like a friend's hand
with your musician fingers,
with your calloused palm
as you step back
stand in silence
as you find that place in the garden
to bury the birds.

Veronica tells you
the clouds are dark
because night falls
into them.

Night falls in your kitchen;
the blue tile glistens
in the twilight like the curve
of her four-year old eyes.

You want a safe
and storybook life
for your child: your daughter
the astronaut, physicist

screenwriter, sculptor.
Your daughter with access to
majesty, magic,
a man with a private jet,

a best friend in her sister.
With an eye like hers,
with her head in the clouds –
you think it could be true.

CHILD WITH WINGS

Wing pivot

 above the pane
 against branching
 sky. I thought I
 was a flutter-bye

at night bright moths

 all of them breezing
 the bedroom screen
 wings sang
 and white dust

scattered the light

 was flight
 was what I
 wanted – always startled air
 the sweep-glide

of music

 she hummed turning
 the tiny lamp
 to the screen
 we watched moths

gathered ensemble wings.

STEEL

The locks of mill buildings, the peaked roofs,
the double row of dim windows
stand straight as a foreman;
the huge knuckles of pipe
fist their steam into the night.

The women know the yawn of the orange furnace,
the dead eyes of men in the lunch line.
The molten ore splashes,
seared with coke and flame,
unlike the flicker of votive candles
where they pray for the lost pension,
the supper stew, the safe birth.

The billets of steel thunder
and tough with tungsten
forge the beams, the scaffolds,
the huge coils of pipeline.
The women hear these
each in her own dreams.

From the slotted lights in the mountain houses
they watch the stars slip
beneath the river, the hazed moon,
the mill that looms across
the Allegheny bank –
the alloys of grief and will and silence.

New York: A Matter of Perspective

If you sit long enough,
words are bound to find you.
Fourteen floors up
on a terrace borrowed from a friend,
the city is almost yours
and you need it
and maybe a poem.

Because the humidity was ninety percent today
and you live in a back apartment
where the Christian Science Church
blocks any breeze and
tells you to heal yourself;
because you stood in four lines at the Department of
Internal Revenue;
you left a book in the subway –
you had to ride it –
because the people you love aren't home
or live in Nevada.

Now, here,
above this city,
you are still of it:
different from the man asleep
on matted dreams and a park bench;
from the Black kid riding death
and the back bus bumper;

from the lovers walking pavements
with their lost footsteps.

You're a woman
sitting fourteen floors up and indebted.
You try to feed yourself
on the park – a ragged field of leaftops stretching –
on the square and dome-curved buildings
that look almost like a stormline of trees,
on the winglights of a jet
that belong on a page or on sandstone clouds.

Living here
in your skin
there are days
you must sit long enough,
days when you need words
where you need to be near
the sky.

FROM THE WHITE SINGLE WOMAN MIDDLE CLASS RECESSION BLUES:

AN INVENTION IN PARTS

1

Today no men smiled at me
as I ran, as I paced past
the Museum of Natural History
along the park.

Maybe they did not like
my aging shorts, my baggy T-shirt.
Perhaps my ace bandage, the hair
plastered to my forehead offended them,
or the scalpel I carry in my left hand.

After all,
I was running against the wind,
running ahead
of Natural History.

2

At ten o'clock
I went to get the mail.

The letterbox handed me
the bill from New York Tel,
a note from my landlord,
a card from my Aunt Danica,
and a flyer advertising
a revolutionary new
tampon.

Leslie was right:
it all gets down to blood and money.

3

Do you want to
be
a corp'rate woman?

I hummed
pulling on my stockings
hooking by bra.

Do you
want to be
a cor-por-ate
lady?

I whistled
as I zipped my skirt

buttoned my button down
knotted the scarf inside
the collar of my shirt.

Do you want
to be
a corporate woman?

I sang
as I slipped on my suit coat
slipped into my low-heeled pumps,
as I listened to a piano
tinkle loose keys upstairs.

It's just another
ragtime, baby.

5

Monday I was sucked in.
I checked time-slips intently,
reviewed cost savings
with a scrupulous eye,
and even petty cash was essential

until I came home to find
a poem from a friend that read:

"Waiting for my sister to die.
Sixteen and she did it herself."

Which told me (again)
that time's cost is not petty
when death is the bottom line.

Your Mother Taught You How to Fish

Your mother taught you
 how to fish
 but for supper
 out of school

 not for sport
 kept you
 to scout the deep pools

Your mother taught you

 to break the forked branch near the house
 to move slowly in soft shoes
 near the creek bank to keep your shadow
 far from clear water the sun
 never behind you never behind you

Your mother taught you

 to use live bait
 to crouch down be still
 watch the fish
 the flash necessary

 no rod
 just line hook sinker
 the brook trout
 as simple words

Your mother taught you

 the quick cast no rod the line spinning
 the hook in your service
 the tug of bite the fish mouth open
 taking the live bait and the stones the stones remember

Your mother taught you

 to pull to pull
 the fish
 to hold the struggle
 like words

 not to play
 there was no reel
 the fish muscled and gasping
 in your left hand

Your mother taught you

 to reach into the mouth find the hook
 with fingers slip it out
 to slide the forked branch
 to carry to carry the catch home

Your mother taught you

> on the bank
> to pull in two movements
> the fish
> its fighting flesh

> > under the fir and tamarack
> > to respect the rainbowed scales
> > the fish like words
> > would become your body

Your mother taught you how to fish

Learning to Fish: Dropping the Line

You fish the stream, tell me
there's no room for casting. Keep your
pole tip up, steady the line.
Let that worm dangle 'til he's almost still,
then drop the line. That's it. Drop it quick
above the fast water. Now try it again.

Above the fast, narrow water
the brush thick the granite boulders slippery
and wet, I find my balance,
hide my shadow in sharp rocks
while my line swings (tip up)
while my line slows (clears the tangle). I drop

the line drop the line
above swift water see the hook break
the quick surface, the line dropped near
a rose quartz rock, smooth and glinting
the line dropped quick to stream like a wing beating.

All their wings beating	in twilight thick with soot
in flats lined with cracks	fretted with ledges then
I found windows	butterflies with wings beating
I said little	I listened like stones
watched still water	watched butterflies
above the rushing	above the narrow alley.

I was little: flutter-bye I said the line dropped
above the swirl of tangled shouts, the fast wind
flutter-bye, I said above the eddy of no trees
its sound, its sense, my voice dropped and
spinning beneath the thick air.

Keep your pole tip up you tell me as I
follow you down the canyon. A butterfly veers
toward me brushes my fingers
my fingers light on branchtips.
Here there is not room for casting, only tangle
streamedge, the quick thin line.

LEARNING TO FISH: THE SWIVEL

You put my rod together,
align the eyes and let me pull the line
from the reel, thread it.
The swivel looks like a safety pin,
too small for any diaper I've seen,
but big enough to hold a broken bra strap.

> I felt the strap snap –
> not with a ping, but a quick slide up.

> In Algebra One, I watched the black board,
> felt the cup slip, the breast float out
> nipple against blue cotton.

> Was Jimmie Shin looking? Staring right there?
> Always with those awful eyes?
> Was I running a fever? Was he –
> neck red like Sandra said. She sat behind him.

> I prayed for words:
> "The homework for tomorrow will be . . .
> and you can get started in class,"
> So I could raise my left hand slowly.
> The gold safety pin safe
> in my coin purse.

The swivel looks like a safety pin,
you tell me.
It holds the sinker, the hook.

LEARNING TO FISH: LIVE BAIT

You hand me a night crawler
from the bait box pull your own
long and active from the pellets
of moist soil. I watch you
stick the hook-point into the worm
inch it 'round the bottom barb. You ignore
the flailing head the squirming tail the gut ooze
that muddies your fingers.

Kids catch these at night you tell me.
After a rain with a bright moon they take
flashlights flash the ditchbank and grab.
You have to be fast with your hands
and pail. The worms are quick too
wriggle right back
into the wet dirt when the light hits them.

Street lights hit me. I ducked into
shadow of poles squat signals in the railroad yard.

I was	The yard boss never caught me
small and a girl	his daughter went
so I was fast	to a different school
a quick mouth	his flashlight hung from his belt
I lied to save pokey Sasha	the nightstick too he wore it
in the yard	carried the storm lamp
I swiped coal	he grabbed old hobos asleep kids
from open box cars	shinnying up hiding running

He called us all night crawlers.

You bait them my father railed. You give them
excuse to call us hunkies thieves to say
your people lazy no work. Someday they break
your head break laws in new country break
my heart. My mother used the coal I stole
to cook soup burned it in the heater stove
near the room where we all slept.

You finish baiting your hook. I begin
with mine stop to remember some species
struggle alone. I expect blood trickle
the muscled twist of live bait. I'd fight too
to keep from dying.

LEARNING TO FISH: GATHERINGS AND SEPARATIONS

The blue canoe in front of the red tent camper
belongs to the lovers.
Inside they love quietly
because the fish have been up for hours
and city campers casting to catch them

have followed. You have followed me here
in your thoughts. I can feel you
hovering somewhere above the water's surface
behind the wings of two damsel flies mating
alongside this boat.

The lake we swim is not
of the woods but is the water of connection
the shallows furred with mossy words
the deep places dark with light swallowed whole
like swells of longing or fear.

The damsel flies spin off in different
directions the lovers rifle
their separate backpacks.
I drift in the sky's reflection;
the trees watch me wherever I go.

LEARNING TO FISH: CATCH AND RELEASE

We did not need
the special notice posted
on the East Fork
of the Walker River:
barbless hooks lures only
no fish to be kept.
It is a sin to kill what is wild
and limited.

Your appraising stare hooked me
my frank return of eyes
made you want to
follow the flash taste me.
Metal or not
all points aside
year after year
we catch each other again
and again
and again release each other
into the current.

LEARNING TO SKI: THE BRIGHT-SUN NO-WIND
DAY AT BLACKCOMB WHEN SKIP WAS SKI-
MASTER AND TERRY AND JON MADE SURE
WENDY AND MELANIE CARVED THEIR WAYS
DOWN DESPITE THE ICE WHILE WE-IN-BLACK
FOLLOWED JUDY'S RED CAP AROUND CRYSTAL
RIDGE TO SOLAR COASTER BEFORE LUNCH
SO THAT LATER WE COULD MEET JOAN AND
GLEN, MAC AND SANDY FOR GREAT SALMON,
INSPIRED ART, DELICIOUS LASAGNA AND
DANCING OVER THE BANISTER LATE INTO
THE NIGHT AND ONE ANOTHER'S PRECIOUS
HEARTS

This crowd of names
is more than a title
this crowd of names
is a night sky
the constellations of friends
fixed but moving
and the stories
and the stories of each tumble
with bright heat
on the chair lifts in the van at the table
like the stories of each star
dance in place in concert
in constellation one to another

as in Wendy and Judy and Sandy and Joan and Melanie
as in Terry and Skip and Mac and Glen and Jon
So that we
laughing in G major
with Jim Croce in the background
so that we talking in fugue around the table
connect lines of conversation
like we connect lines for constellations
big bear seven sisters the fish.
This crowd of names rises
rises to dance
lanterns the way for more stories
of parents of partners even the absent children;
this crowd of names shoots and falls
like stories like the story
of the bright-sun no-wind day at Blackcomb
that was
a moment a mountain
a crowd of stars.

Eight Months after the Skiing Accident

My knee finally rejoined my body
in June only to set up
a new log of complaints
a new list of regulations
OSHA approved
regarding conditions for work
working working-out.
Like any good employer
my brain has tried to listen
tried to make reasonable accommodation
in the physical environment
at its own expense.
Other joints: hip knee
shoulder and elbow are divided
between understanding support
and resentful compensation.
Negotiation is a skill and art
coordinated as peristalsis
and instinctive in women I think.
Serious talks begin tomorrow.

ORIGINS

for Chelsea Miller

Drawing the tree, the red tassels

 of white birch seeds with colored pencils is

An exercise of eye and hand of line and speech:

 Spider Grandmother weaving a

Vigilant tree into being

 to watch Her to speak Her world.

In Her world there was no death only

 bird dancing women brown as tree trunks

Deciphering the days with handlooms

 horses paint red seeds against the sky.

First Fire

Last stars fade into daylight
the sky a clear window that waits

clouds rest in hewn wedges
behind it most bundle like branches.

In the fireplace the nightlog glows
to gray ash the loose coals hum

coals focused to hunter orange.
She searches the wood pile splits

a board end to thin sticks
uses four and one pitchy branch.

How many times has she reset
the clouds heard the space wind draw

sucking the last sparks how many times
has she rekindled the night refused to waste the stars?

FALL THOUGHTS

I have	
	dark eyes yours are light
	what we see is different
	similar distinctly necessary like
	the fallen tree free for firewood
called	or home for insects ground animals I
you	
	different you called me
	similar call us vision
	or trees distinctly necessary
	root and trunk we branch
	together broad-leafed keen-needled
love	more than windshape or shade because
	similar different all life
	falls to some further
	purpose like love or the fallen tree
	housing what it could not house
and that is	ready to be fire
	vision light and dark
	the fallen tree is the comb of caves
	arachnids safe as we were
	in the dark hard wood
	laced with pitch the logs burn
your name	and fire creates her own form like
	my name etched in bark
	tough as brown skin rugged
	our names similar different
	distinctly necessary as shelter or fire
	we dwell and burn we see
	free beyond falling

46

Storm clouds from the North not
swirled and roiling simply
the steady gray. The porch swing twitches
asks to be hefted to the shed.
The bob-tailed cat listens nibbles
from the dish after a night
of no mice toward a day
of beating the hawk's talons.
 Inside
the woman lifts a split log
with the long-pronged fork
wedges the black-red branch
beneath it. The wood flames
sharp as wingtips keen
as night eyes. Her hands spark
red and black and gold
against the morning.
 Inside
her eyes remember feather and beak
fur and claw the weight
of things hauled to safe keeping.
In the dim morning her eyes remember
a sea of ginghamed aprons
against the sky.

WHITE ROCK CANYON

Rumor
has it

The Paiute woman called this White Rock –
white as a Pueblo bowl, the creek

black with loam that sifts, that sifts,
that sifts down this small canyon

pushed by a wrinkled current, supple
as a woman's hand. She ground

she ground corn; she ground pinions.
Her hands shiver'd like aspen,

shimmer'd with frost like pond weed,
grew steady with the stone and sun.

They left White Rock
when she said so: when leaves

were no more. When thick branches, fine needles
could pick the teeth of the wind.

UTAH WINTER

It isn't the end of the world
just a Utah winter and I've swirled
myself like snow between the sage
drifted and let the sun melt me
just enough to freeze again. Crust
is all to some and I have one must
to come to shoe through this West.
It's still the road best taken

though in no degrees
the ground's slow to move
and me full as the moon
can't trace the gleam
of tracks or autumn shoots.
The wind's shushed them away
like words. So I move on
sense my direction from stars

and the dark. Like seeds I scatter
wait and crack and watch some of me
die. Yes it matters but
it isn't the end of the world.
I'll swirl a spore string of me down and down
'til my fingers sprout
and bud with stalking words
while toes feel the mud like roots and put them down.

JANUARY: LYNX MORNING

The road to the highway's piled the field's
palmed smooth as plain sheets in places
or drifts like pillow slips and snow
snow sifts in steady blow
off the barn light's cowl the glow

I lie in bed
don't see it but know it's true.
Snow not silent snow secret snow. No
snow sounds. It pads the ground.

I hear its quiet
round as any paw yes the fur
the fur but more
the tender underfoot
in rabbit cat even raccoon

all near and quick and sudden
as the snow itself. Still as any
wild thing who knows it's watched
or listened for

in the wind. My lover breathes me
back to sleep
where I hunt something
in my dreams where I
fit the footed white fall drifting

The porch is wet the moon sets
and Henrie's field
tries to green he swears
but feels old and cold
and angry as he is
at March's lie.

Spring's the lie of dates
perpetrated by weathermen and boys
both conspiring to rut the roads Henrie
refuses to gravel and upgrade
to give them to the county. Mine's one.
I want it done soon before mudtime.

Weathermen say "Hey there – Rain enough to green"
but the fields don't. Just the roads
mud up enough for boys wanting and driving
and wanting to rut in once new Chevys
can't because of girls or God or fathers
so rut Henrie's road to the pond instead.

I sigh at both most days.
He has to haul out his tractor
try to grade the roads take a chance
on his old exposed motor breaking down.
Henrie won't pay a man to do the job
for him. Too tight-fisted some say.
Too fisted I say and watch the sage

kerchiefed in wood smoke like me
another woman caught in a range war again
between boys and old men. The road out front
softens steams in no sun
waits tired in the tread of spring.

Suburban Walk
Southwest of Town

The sprinklers mimic downpour
but rainbird is a misnomer.
No birds strut in place like these
backed by the typical flags
of suburban development:
Riverrun Creekside Meadowood.

The river races fish
listens to the rock chuckle
the boulders laugh in the sun.
The creek sides with no one
but herself, nor would the meadow
allow any flag except the banners
of wild sweatpea.

Close to the ground
not hoisted on poles
the banners of flowers are curved
not square cut resist printing.
They crowd without city statutes
at stream's edge and call out

Listen. What are these beasts
of grinding metal these hulking giants
of slow-moving noise
leveling this hill?

Dozer and truck are powers without grace
in the service of whom? Whom?
Ask yourself why.

Listen. The wind may teach you
to be a shape-shifter
without them. Listen.
The meadow creek river
know their own voices.
They've been speaking and listening
for years.

The sprinklers stop flags snap
the stars sigh for a moment of silence
while the five blocks of new street lamps
blink off in unison in one beat
in municipal choreography
again.

GRATITUDES

MOVING RITUALS: MESSENGERS

Watch the tawny trail
sandy and hard-packed
the columbine bobbing.
The grouse with her red mask
dances the spiral dance
into the thicket.
The eagle glides above the aspen
her wide wings catch.
Grace is not a wild card.
It is holy. It is beyond words.
This place is a spindle of messages twirling
like prayer sticks.

THANKSGIVING

The lean-to covers wood
for the cook fire.
Hides dry on wood racks.
The women will tan them soft;
the women return to their stone bowls
to grind maize
to pummel roots for dye
to cull herbs for fever.

A woman sits on a spotted horse,
watches the other ponies drink.
She wears buckskins,
a blanket slung across one shoulder.
She feels her mother's hands around her.
Waterbugs dart;
fish eddy the stream.

Red-winged blackbirds gather.
Wild turkeys strut.
They bend forest grass
with their federal walk.

Today, I sit my own counsel
and think of broad-faced women
with thick braids
who are
who are no more.

Thanksgiving Again

When women come to thank and feast and talk
About the spring's quick brook, the summer's child
The autumn's harvest, crones begin to walk
Again and plant earth's sleep with myths beguiled
From shooting stars. Crone dreams begin to play
Upon the wind, appear on mountain trees
The ones most near to sunset's fire and gray
Spoked clouds. They rise, unburdened, lift with ease
Like women passing plate and dish and some
Small story in between the slant of sun
And gold-toothed smile. Each year they seem to come
Among us, winning what's already won
Or gleaned from our best selves, I'm told.
Crones feed us with their wit – to have, to hold.

THE THANKSGIVING WHEN THE DAVIDSONS TRAVELED, BUT MICHAEL CALLED BEFORE HE WENT TO NOVATO AND JOE CALLED TO FIND OUT IF I'D FALLEN IN LOVE WITH SOMEONE ELSE AND JANE AND I WENT SKIING WHILE SANDY COOKED AND THE OTHERS PLAYED GOLF AND THE FAMILY MCGEE ALL GATHERED TOGETHER AGAIN AND INCLUDED ME

The blessings went on for hours
from Michael's greeting to Joe's –
friends eclectic and electric over the wire –
with just-out-of-bed voices gravelly with dreams.
Jane (hair in braids) was easy to laugh with
in a snowball fight was easy to talk with listen to
as we drove to Mt. Rose as we rode the Lakeview chair
as we said nothing carving our way down the bowl
while the sun burned through to the cloud-caped mountain;
and the rush of our love for this sharp movement
was silver as foil as tin roofs at dawn or
a room full of dimes waiting to be spent.

The blessings went on for hours
at the house on Barnes Circle
where Marie's daughter and Mac's son
welcomed again their parents and children
their brothers and sisters and nieces and nephews
and the new grandbaby

and the new grandbaby
was there to remind us that all blessings start
with hungers with muscles we sometimes take for granted
like friendship and family
and the faith that we will love again
and gather.

The blessings went on for hours
small and silver large and well-spoken
like the saying of grace before the meal.
They were spoken and gestured
gestured like dance
like dancing where
all of you know the steps and still
make up the moves as you go along
as you feel the rhythm of blessings
with the soles of your feet
with the skin of your soul
with the heart twirled and turning to give thanks.

CENTER

"I am remaining closer to
the center these days.
My motions are inward.
The others hold on."

— Letter From Cheryl Lundstrom

Centering
was a word
you and I had
long before self-styled gurus
found it before they
thoughtlessly lifted it
poured out the clear meaning
and forgot to admire
the stoneware bowl.

Centering
we were the wheel
round and spinning
words pumping the foot peddle
with measured steps
poems that would hold
something inside the inside,
circle what other form
suited us better? Definite; infinite.

Centering
we still are
while others hold on
like handles or names
attached but not rising
from the vessel's form.
We continue to move inward
words shape us unafraid
of fire. We know the use
of elements
of the clay's dust.

LINES

I write
short lines

thinking of all
the women

who write
short lines

before they wake
children

before they
scrape dishes

before they count out change
for the bus thinking

wake
scrape

count out change
daily like breathbeat

then you are silver
in the early dark

Letter to Jan in September

The humming birds migrate I took down
the glass feeder to remind them to live
by instinct My poems dart with words that rhyme
with wings with whir with trail and leave
I can't help it One day I saw ten
different kinds called them by color and parts
of their hand-small bodies purple spurthroat gold
wing
green tail I had no book or you
to help me name them
to tell where they'll winter soon

The family reunion and I opened to mixed reviews
you tell me The uncles played cards in the garage
while the aunts exchanged recipes snapshots
of children their children have had You
walked the deer trails between sweeps at conversa-
tion
counted the plants you could live on if you had to
Tired of one-word answers you showed the bandit
raccoon
the scavenger jay pictures from your book a
photo
of the typewriter you left at home

Last night I dreamed I flew east on my own power
you walked west through the giant fir In the ferns

64

on the forest floor we drank from your canteen
ate apples from my backpack split kindling and
stopped
to call the birds by real and imagined names
In the green that gathered twilight you read
two chapters I read
two poems and we talked about the difference
in our outlaw children Near the crackle and hiss
of the campfire we sang ourselves to quiet
wrote in our notebooks till dawn.

The Poem: Incomplete Definition

The poem is an unmailed letter
written with pilot pen
by a candle blue
as a pilot light or typed quickly
the dark cursor coursing across
the monitor's screen.

The poem is an unmailed letter
the phrase appearing
in a dream the line writing itself
begun by someone else's word
the thoughts rushing
like dry creekbeds wet and swirling
in the unplanned mountain shower.

The poem is an unmailed letter
the sound driving
all words you have read
into something else –
a three page journal entry
panned down like gold
to two nuggets: silk-swell.

The poem is an unmailed letter
to your self as if postage
is too weighty as if
assuming a listener the task is done

but undone closed but not
finished the poem is an unmailed letter
from passions and gratitudes
from learning or the land from
love and fear always
from some scout on the horizon
inside us.

LETTER TO IRENE IN ITHACA

The moon rocks the sky like a story.
In the half-light of morning you wake –
the house chill still;
you welcome the shadows
of blue-black mountains.
Fir and pine
birch and maple paw the sky. You pray to these
if you pray at all; live here by choice with voice,
the woman you love typing when you leave for town.
This is no island,
but somewhere outside
town and gown, out of bounds,
the boundary.

"In the deep place where feeling begins,
I am with you every day," you tell me.
I see you unlock the door of the bookstore,
unwind your knit scarf,
set your feather earrings swinging.
You know wings, words, women.
The hot water on for tea,
you see the upstate buildings
square the street in board and brick.
The college spires
stab the sky and call it education.
You run a women's bookstore – call it
dark love or breathing.

Tea done, time spun, the early sun
comes slowly – warms the grain of your hand
and the back room.
Books unpacked, just half
are stacked next to the carton.
You count and check
count and check
shuttle back and forth
from books to invoice.
Some days you thread the shelves
make notes to remind you what
to order.
Some days you follow the lines
of catalogues with fingers
find what's there, what's new, what's needed
before you unlock the door
for words and women.

"No I don't have but will order – Yes
we do lend. Spend as much time
as you need just looking," you say and think:
"Why did I ever?"
"More places to sit," you tell yourself, "and toys."
The voices weave
close and words like new wool
fresh and difficult,
the smell of pages and ink and women. This
is your tapestry,
daily and done in concert or done alone.

But you don't weave and wait,
wait for Odysseus to come home
or the son to stop combing his hair
in front of the mirror, in front of the suitors.

The last woman leaves. There's so much
left for you
for you to do
which is classic, ancient, new.
I see you pick up a book women wrote,
pages other women published:
perfect bound, clearly printed
This Bridge Called My Back.
I see you pick up a book a woman printed herself,
sewed each copy together.
I see you touch
cover, pages, words like a lover.
You know these are worth the trees.

KINSHIP

You talk of anger.
You with your black hair
darker than storm clouds crowding
over the steppes,
dark as the hair of Slavic women
who planted
who baked brown loaves to feed warrior husbands,
who blessed their sons
with the sign of the cross before battle.

You write and
do battle,
feed yourself,
bless daughters with these words:

> they are sharp blades
> they are chants more ancient
> than the cross.

When you talk of anger

> plough down castles,
> turn over the prince,
> the princess dead in her sleep,

the Russian mothers before you
become your bones, your eyes,

your black hair.
I see you planting
breaking ground.

WHEN TIME AND TRAVEL SLOW

When time and travel find me in one place
Where both have slowed – where I can slip
Away into what's real, I find your face.
Your face, the flesh like mine, lines fine that skip
Your eyes, lake deep. Lines feed like creeks that seek
what's still, what's proud of its own depth. Eyes
where
Dark flecks could spin like fallen leaves, could speak
Of surface things or dive deep like trout to share
the swim, the scales, the hidden coves of thought.
Your mouth's not full, but definite with play,
With days talked honestly, with words that ought
And are actions. Your mouth curves deep, a way
of water, speech. When time and travel slow
I find your face – hold what I hold and know.

OTHER PEOPLE'S CHILDREN

I exist for you
in tandem
with myself:
my name on your transcript,
points missed in red,
the marginal comments
letter the power
we both acknowledge
but do not speak.

It is there
even in tales
of my Midwestern brother,
the last time
my Chevy broke down.
It almost disappears
in the laughter,
in poems that become
somehow ours.

You are a part of
other people's children:
parents I do not know,
resemblances I cannot see
as I watch you today –
glad not to be your mother,
know what you won't have for breakfast,

if you fight about the car –
glad not to worry about when
you'll get in.

I stand in the privilege
of distance and choice.
Without the awful nearness
with the door open between us.

THANK-YOU NOTE

The pearl grey shawl
you crocheted drapes
the scapula
of my wing chair warms

my spine as I
lean against it
noting reading
working early

again. We give
shape to each day
with wool with words
with hands our bones.

I will miss you when you leave
for the sheep herd.

FOURTH OF JULY

Straight up
wide maple leaves
mosaiced the sky,

turning twilight
turning leaves
deep green.

I felt
one finger
skim my ribs,

watched your
face bend .
until I closed my eyes.

Your tongue-tip
scanned each eyelid
slid down my nose,

lips met
my cheek
and stopped.

On the edge
of the lake
children dangled their toes,

held sparklers – waited
more patiently than I
for the night.

WILL

The chocolate lab
pacing
the other side of the redwood fence
wonders what animal I am,
but does not bark
in territorial greeting or fear.
Neither do I.

Her unseen tags jingle
on her unseen collar.
We share curiosity
and toenails that need clipping.
Hers scrape her patio slab
while mine push out from furless nubs,
still and unpolished.

We accept morning sounds:
the neighborhood noise of jays
and a roofer's hammer,
now a set of tires on pavement to the west.
Our excellent ears distinguish and release
the almost dissonant sounds around us.
What pitches does she listen for?

To be a good animal to this neighbor
is one of my short-term goals
along with writing, along with righting

a few character defects
I need to discover, uncover
and (with help may) trade
for the will to change.

Willingness
like late April sun, this birthday sun,
ages and calls me.
Willingness
as a life goal is a jazz flute, a tone –
a long vowel in a range of sound –
that now, curiously,
I can hear.

At Sixty

At sixty
freedom means announcing
you will only
only take early retirement if
it secures the jobs of two
young colleagues.
Two young colleagues equal
two women, one conservative;
and that yes, this is Practical Socialism;
and yes it is
lucky they know an old lefty
from the sixties.

At sixty
freedom means admitting
that you don't know
if the house he's building in Marin County
is for the two of you.
You know he will invite you.
You know you will visit.
You know you have your house paid for
in another state
and that you
never
want to get married.

At sixty
freedom means saying
you have no religion.
All that lives is holy. Praise
praise the otter and ant
mountain lion and lizard.
They curl in your biceps and knees
drink from the marrow of tibia and others.
The eagle opens
those lattice-boned wings
representing no nation
but the sense-filled soul.

At sixty
freedom means
words on paper, words
on the wind
words that are actions
and actions
spurred from days
from dreams from
silence: out of Nothing
Something. And it is
honest; and it is
your life.

MARKRIDGE GARDEN

The purple flag iris
you asked me to cut
from the bed
of lilacs pruned
last month
is not as beautiful as
your new grandson.

Your new grandson born
in a different bed
the day after you took
radical action and sharp shears
to help the lilacs
extend their shade
to the iris you love almost
as much as I do.

As much as I do love
iris lilacs your grandson begun
countries ago in beds
you will never stretch to imagine
(regardless of pruning)
I love more your belief in the beauty of growth
the actions required to tend it
my accidental need to arrange them
looking at light shape line.

MOVING RITUALS: RITUAL FOR RELEASING SADNESS

Sleep for eight hours
with dreams of a fawn
large-eyed slim-legged colored
like cedar bark and old stones.

Wake and run
your legs three times as thick
as the fawn's but smooth
the color of clover honey
your breath easy as your arms
swinging you uphill down
between the sugar pines
along the ditch bank
your heart pushing your blood
your skin shining.

Sweat in silence
the hot room empty of everything
except your body;
your heart now clear as snowmelt
pores open as a lover's mouth.

Moving Rituals: Solstice Dance

On the lift at Sugar Bowl
I know I'm in for
a different two-step:
the hat gloves gator sun glasses
the clothes tailored but layered
the boots
as far from dancing pumps
as the mountain
from the parquet ballroom.

An immaculate sky
the long arms of the groomed runs
the palm of soft powder are open
as a hand offered a visual invitation
inviting more than a rock-step-side
a lady's loop a fifth position break –
inviting first descent and flight
mine or anyone's
inviting the cut of carved turns
with gravity leading.

In ten degrees Fahrenheit the sun leans against
the sky's lapel in sparkling
meditation on the day
on the day of the darkest evening
of the year where I will not stop
by woods in New England

as that strange man Frost did;
where I will not stop mid-routine to check my hem
or my footwork.

This is no tango promenade
though legs powered from side to side make music
though shoulders downhill mark contra-body movement.
This is rush and edge
fifty candles on the altar
my head open for spring cleaning my heart lost in oratorio
the alto ventricle leading into the turns
and turns and turns.
Some days
skiing is
dancing's quick cousin always
it is Grace.

Moving Rituals:
Walking

Slowly I return to
calendar planner laptop
the starch-white fax of facts before me
notes penned
in the right-hand margin
by the right hand: mine.

Somewhere in this network of nerves
framed in bone fleshed with
organs muscles corpuscles
wrapped in skin which is me – somewhere

in every cell I am still
with you. We are still in Friday
walking beyond the elm and elderberry
the seeds of cottonwood backlit by sunset.
We are still watching the runners run
and the river – the old man fishing for shad –
his stringer almost full.

We are still:
your arm circles
my willing back
your fingers leave notes
on my neck
your fingertips slide

under my thin shirt
with the right hand: yours.

Today, the American River cannot be replaced
by this suburban pool. This deck
is useful but not the bluffs
wild with berries and slow
middle-aged lovers marked
by purpose responsibilities:
the palpable silk of time
in our open palms,
the delta breeze
behind us.

Moving Rituals: Translation

The photograph of the sunset
of Monterey Bay leans against
the volcanic rock that backs
the oak mantle of your fireplace.
In sepia tones the earth's curve is there –
the air and water fused
with elemental light, the sun's fire banked
behind the clouds whose hues
I can recall and call.

I remember sitting in your car
at this coast, your face turned away from the bay,
three fingertips trailed my bangs, my temple,
then cheekbone tender and definite as the whistle
of dove's wings. Your mouth
was hungry but slow
elemental in the history of tongues.
Mouths spoke our vocabulary of gesture
as I closed my eyes.

We believe in words and no words,
the religion of kindness, God
in sun, sluices, in every electron
of every atom – the ions of one wave
drawn to moon and dune grass.
In the midst of horizons

and grandchildren, we know
each other. I write this
in our clearest dialect.

The Author

Melanie Perish is a writer, student, and teacher. She knows it is a privilege to be the Director of Development and Alumni Relations for the College of Engineering at the University of Nevada, Reno. Born in Chicago, resident of Matteson, Illinois, Bloomington Indiana, New York City and Panguitch, Utah, Melanie is glad to call Nevada home. She is grateful to the women's writing community for teaching her that writing is solitary, but thinking is collective. She is grateful to have a spiritual program which continues to teach her that she can act her way into right thinking, but she cannot think her way into right action. Like forgiveness, the loving kindness she extends and that is extended her is a gift. Friendship is the organizing principle of her life. Melanie lives in Reno and cannot imagine a life that does not include the Sierra Nevada Mountains and the Grace present in their sky.

Colophon

Designed and produced at the Black Rock Press by Bob Blesse with assistance from Hayley Greenside. The text font is Minion with display in Rialto and Zapfino. Printed and bound by Thomson-Shore, Inc., Dexter, Michigan.